ISBN 978-0-266-92856-0
PIBN 10911212

BY

BRITISH ARTISTS,

The Subjects taken from ENGLISH HISTORY ;

Painted expressly for

ALEXANDER DAVISON, Esq.

WHICH

Will be Sold by Auction,

BY

MR. STANLEY,

AT HIS GREAT ROOM,

MADDOX - STREET, HANOVER - SQUARE,

On SATURDAY the 28th of JUNE, 1823,

AT ONE O'CLOCK.

May be publickly Viewed three Days previous, with Catalogues, (at One Shilling each) to be had at the Place of Sale, and of Mr. STANLEY, at his Rooms, 21, Old Bond Street.

CONDITIONS OF SALE.

I. THAT the highest Bidder be the Purchaser; but should any Dispute arise between Two or more Bidders, the Lot to be immediately put up again, and re-sold.

II. That no Person shall advance less than One Guinea at each bidding.

III. That the Purchasers give in their Names and Places of Abode, and pay down, if demanded, Five Shillings in the Pound, in part of Payment of the Purchase Money: in default of which, the Lot or Lots so purchased to be immediately put up again, and re-sold.

IV. That the Lots shall be taken away with all Faults and Names, and under all and every Description, at the Expense of the Purchaser, within Three Days after the Sale.

V. That this Sale being made expressly for Ready Money, the Remainder of the Purchase to be absolutely paid on or before the Delivery.

VI. THE AUCTION DUTY TO BE PAID BY THE PURCHASER.

Lastly, That upon Failure of complying with these Conditions, the Money deposited in part of Payment shall be forfeited, the Lot or Lots uncleared after the Time limited shall be re-sold by Public or Private Sale; and the Deficiency, if any, attending such Re-sale, together with all Charges incidental thereto, shall be made good by the Defaulter at the present Sale.

Advertisement.

IN the Year 1806, (a Year which ought to be commemorated as an epoch in the History of English Art,) Mr. DAVISON formed the resolution of giving some encouragement to the talents of Native Artists, intending thereby to bring them fairly into competition with those of other countries. His plan was to employ a select number of the most eminent on interesting subjects of English History. For these purposes he communicated with the distinguished Painters, whose Works are included in the following Catalogue, and he found them zealously inclined to carry his intentions into execution. No plan could be more honourably devised; the Patron exacted no compliance that would in any degree shackle the Artist. The free choice of subject was left to the Painter, with the simple restriction that it should be from English History, and with the flattering condition that his own Portrait should be introduced. Under these auspices, and with that generous spirit of emulation which always glows in the breasts of Men of Genius when called upon to exert themselves by those who unite delicacy with liberality, these eminent Painters commenced and finished THE SPLENDID SERIES OF PICTURES NOW TO BE SOLD. That each exerted himself (if exertion it may be called where pleasure is the chief incitement) to the utmost of his talents, their own letters, which accompanied the Pictures, testify. Mr. DAVISON was satisfied; and the concurrent approbation of the best judges of Painting, pronounced the accomplishment as honourable to the Patron and the Artist, and glorious to the Country. It is hoped that the example will not be lost; that there are kindred spirits of both kinds; and that even the circumstance of the Sale will cause some noble-minded lover of the Fine Arts to continue what is so well begun. No proof, beyond these examples, is needed, that English talent may compete with the world, when it meets with due appreciation.

CATALOGUE, &c.

SATURDAY the TWENTY-EIGHTH of JUNE, 1823.

𝔓𝔦𝔠𝔱𝔲𝔯𝔢𝔰, &c.

LOT

1 Sixteen Prints of Naval Engagements, framed and glazed

2 General Orders to Volunteer Corps, and the Relief of Williamstadt

3 Christ healing the Sick: a Proof, after West's celebrated Picture, elegantly framed and glazed

4 The Duke of Wellington giving orders previous to a general action: Proof, glazed with plate glass

5 A large Drawing, Contemplation, by R. COOPER, framed and glazed

6 Landscape and Cattle, by TOWNE

7 A Cabinet, containing numerous Specimens of Minerals, Fossils and other subjects of Natural History

8 A View in the Highlands of Scotland, by ARNALD

14 A richly wooded Landscape, with Figures and Cattle passing through a wood, by GAINSBOROUGH. A splendid example of the powers of this Artist, who gave novelty to the frequent appearances of Nature, and elevated her meanest productions by his masterly mode of representation

15 A woody Landscape, with Figures seated near a fire, by G. MORLAND. One of his richly coloured and carefully finished Pictures

16 The Embarkation of St. Ursula and her attendant Virgins, by DOUGLAS GUEST, after CLAUDE LORRAINE. The subject has been copied with so much precision, and at the same time with so much kindred spirit, that were the original lost, or should the Country be deprived of the possession, this would supply the place so well as to leave little to be regretted. It is, perhaps, the happiest effort of the Artist at imitation

Passed 17 MELANCHOLY. By RICHARD WESTALL, Esq. R. A. The subject
is taken from *Il Penseroso* of Milton, and very happily
exemplifies the Poet's conception of

> " The pensive Nun devout and pure,
> Sober, steadfast, and demure ;
> All in a robe of darkest grain,
> Flowing with majestic train,
> And sable stole of Cyprus lawn,
> Over her decent shoulders drawn,
> And looks commercing with the skies,
> Her rapt soul sitting in her eyes."

It is one of those fortunate coincidences of the Sister Muses,
Poetry and Painting, meeting together; the Painter, himself a
Poet, illustrating the Poet's conception to the fullest extent, by
embodying his description and making that which was only
visible to the mind's eye obvious to the natural sense. The
description and the Picture are so consonant that either will sug-
gest to the tasteful spectator the same imagery, the same plea-
surable sensation

140 Gs 18 Portrait of LADY HAMILTON, as a Bacchante, painted in enamel
by H. BONE, Esq. R.A.

A pure and inestimable Jewel of Art, embodying all the beauties
its executive powers can bestow, and almost surpassing Nature
by the faultless combination of form, colour and expression.—
Painted expressly for Sir William Hamilton

The following eight Pictures were painted expressly for Mr.
DAVISON, in pursuance of a plan adopted by him for forming a
Gallery of the Works of distinguished British Artists. The sub_

ject was to be taken from English History, and the only condi-
tion imposed on the Artist was that, to distinguish his Work in
this Collection from others, he should introduce his own Portrait
in the Work. How honourably they acquitted themselves the
Pictures amply prove. The descriptions were written by the
several Artisst.

19 *Henry Percy, fifth Earl of Northumberland, presenting the
Princess Margaret, eldest Daughter of Henry the Seventh, to
James the Fourth, King of Scotland, at Lamerton, two miles
beyond Berwick, where he and his Nobles were attending to
receive her as his Queen.*

PAINTED BY JAMES NORTHCOTE, ESQ. R. A.

In the centre of the Picture is represented the Princess Margaret,
eldest daughter of King Henry the Seventh of England, under a
canopy of state, modestly presenting her hand to the King of
Scotland, to whom she has been affianced in marriage, who gra-
ciously receives her. Behind her is Henry Percy, fifth Earl of
Northumberland, distinguished by the arms of the Percies em-
broidered on his mantle ; he was Knight of the Garter, and also
Lord Warden of the Marches, into whose charge the Princess had
been given by the King her father, and who now delivers up his
high trust into the hands of the Scotch King.

The ladies are those of her retinue who attended the Princess
into Scotland ; the standard over them displays the arms of Henry
the Seventh, supported on one side by the Red Dragon, the
ancient badge of Cadwallader, the last King of the Britons,
from whom he was descended, and a white Greyhound on the
other, from the arms of his father.

The canopy is embroidered with portcullises, the badge of the House of Lancaster; and the Red and White Roses impaled, as borne by Henry the Seventh of the House of Lancaster, on his marriage with Elizabeth, heiress of the House of York, by which marriage the Families became united.

Behind the King of Scots, who is decorated with the collar of the most ancient Order of St. Andrew of Scotland, are seen the Archbishop of St. Andrews, and other Scotch Lords attending the King, in which group the portrait of the Artist is introduced; and below is the Royal Shield of Scotland, with other warlike implements laid on the floor, in token of peace and amity.

The King's trainbearer holds his sword, copied from the sword which was taken by the English at Flodden-field, and now preserved in the Herald's College; together with his ring, which is also represented in the Picture, on the little finger of his left hand.

See the History of the Royal Family, or a succinct Account of the Marriages and Issue of all the Kings and Queens of England from the Conquest, small 8vo. p. 221. See also Holinshed, p 791; Baker's Chron. p. 246; Rapin, vol. 1. p. 687; Bolton's Extinct Peerage, p. 212; Lord Verulam's Life of Henry VII. In the Herald's College there is also an old manuscript preserved, which describes all the ceremonies attending on this marriage, written at that time.

20 *Lord John Warren, Earl of Surrey, resisting the unconstitutional Attempt to Question, by a Quo Warranto, the Tenures and Liberties of the Ancient Barons.* Anno, 1275.

PAINTED BY HENRY TRESHAM, ESQ, R.A.

In illustrating this subject, the Painter has studied to give an appropriate importance to the Commissioners. Men of dignified

deportment, venerable and impressive from their years, and presumed acquirements, have been selected as characters to whom a wise Prince would alone confide the execution of so momentous a commission.

In the most elevated situation of the group is seated the Chief Justice, or First Commissioner, who assumes a studied composure, inflexible to every impression but what results from the duties of his office : before him, and lower in the picture, is a table, at which preside two other Commissioners, and a Secretary : the aged figure leaning on a book and bending forward, by the inquisitiveness of his looks seems to interrogate the Earl on the propriety of his proceeding. The old man at the farther end of the table admires, with a countenance of conscious disappointment, a conduct that, he foresees, will put an end to the career of exaction. The Secretary, ready to register the deeds when delivered in, is unable to govern his surprise at the novelty of an appeal to the sword as a document of the title to an estate. The Earl Warrenne, having drawn his sword, is delineated at the moment of making his memorable reply.

It seems to have been the practice of the ancient Barons, when determined on opposing the measures of the Crown, to attend even the Parliament in military array ; therefore, the principal figure is represented in armour. Near the Earl stands his retainer, or his friend, interested in the issue of the event ; and no less indignant, he watches with solicitude the impression made on the Chief Commissioner, near whose person is introduced a likeness of the Painter, blended with spectators more or less affected consonant to their subordinate characters.

92 9° - 21 *Elizabeth, Queen Dowager of Edward the Fourth, in the Sanc-*
tuary at Westminster, receiving a Deputation from the Council
of State, sent to demand her younger Son the Duke of York.

PAINTED BY ROBERT SMIRKE, ESQ. R.A.

The point of time chosen for the composition is soon after the
entrance of the Deputies, and when the object of their mission is
announced. The distressed Queen is seated in a manner that in-
dicates her forlorn situation: languid, and exhausted with severe
and complicated grief, she is leaning her head against one of the
pillars of the hall, and turns an hopeless eye towards the Cardinal,
while he delivers the Protector's message ; the insidious nature of
which she cannot doubt, and regards it as the prelude to the
sanguinary drama that was soon to involve the fate of her unfor-
tunate sons. The right arm of the Queen encircles the Prince,
who stands at her side ; and pressing to the bosom of his mother,
he seems to participate in her fears, and to listen with apprehen-
sion to a requisition intended to separate him from his dearest
and best protector.

The Queen having fled with precipitation to the Sanctuary,
whither much of her private property had been conveyed, her
attendants were consequently not ignorant of the dangers that
threatened her family ; the females near her, therefore, are repre-
sented as sharing in the common distress ; and discovering,
though differently expressed, the same fear and distrust that
possess the mind of their Royal Mistress.

The Cardinal Archbishop being the chief personage of the
Deputation, is placed in a prominent part of the composition.
He is habited *in pontificalibus,* and attended, as usual on im-

portant occasions, by one who bears the double cross. Two or three others are introduced (among whom the Portrait of the Artist will be found) ; but except the Lord Howard, the names are not recorded of those who were at that time made the instruments of the Protector's treachery.

22 *The Offer of the Crown to Lady Jane Gray, by the Dukes of Northumberland and Suffolk, and other Lords, Deputies of the Privy Council.*

PAINTED BY JOHN SINGLETON COPLEY, ESQ. R. A.

The composition of this subject represents, to the left, Lady Jane as having arisen from her seat, supported by her husband Lord Guilford Dudley, whose importunities are said to have principally prevailed upon her to receive the Crown, which is offered to her by his father the Duke of Northumberland, who, with the Duke of Suffolk, her own father, are seen kneeling before her, and soliciting her acceptance of it. Behind them the Earl of Pembroke appears, joining his entreaties also with theirs; and Cranmer, Archbishop of Canterbury, with others assisting on the occasion, fill up the group to the right, in which the Portrait of the Artist is introduced. The scene lies in a state apartment of Sion House, as supposed to have formed a part of that ancient religious structure

finally quits her own Country, and embarks in a Fishing Boat for England, with a determination to seek protection of Queen Elizabeth.

PAINTED BY RICHARD WESTALL, ESQ. R.A.

The principal group consists of five figures, and represents the Queen of Scots at the moment she is about to embark in a fishing boat for England; her hands are clasped together, and her countenance expresses a deep sorrow for the calamities which had befallen her kingdom, and herself; the Archbishop of St. Andrews, the Lords Herries, Fleming, and others of her nobility, are on their knees, extending their arms towards her, and earnestly imploring her to remain in Scotland. Over this group the principal light of the Picture is distributed.

Immediately above the principal group is another, consisting of three figures, two of them female attendants of the Queen, companions of her flight, sympathizing, by their tears, in the distress of their Sovereign; the other, a young man on horseback, bearing in his right hand the royal banner with which he is supposed to have fled, when the Queen quitted the fatal field of Langside.

To the left of the principal group, and in a degree connected with it, is a young man on his knees; he is leaning back, his hands are clenched, and his eyes fixed on the royal fugitive with an expression of great anxiety, and of grief and surprise, that those who implore her stay cannot prevail.

Above this figure, is a group composed of four figures, of which

the most conspicuous is a young man leaning on a white horse, who, as well as the old Friar on his right hand, who bears the crozier of the Archbishop, is looking on the Queen, but with a more thoughtful and not less anxious sorrow.

On the right of the Picture, one of the attendants of the Queen is leaning forward from the boat, and extending his left hand to support her as she steps into it : the boat is steadied and held to the shore by a man in the water, intended to represent one of the fishermen. The back-ground is principally a dark cloudy sky, but a part of it is occupied by a lofty cliff, on the top of which is seen the Abbey of Dundrenan.

The whole composition consists of eighteen figures ; the head nearest to the edge of the Picture, on the left hand, is intended for a Portrait of the Artist.

200 9 24 *The Conspiracy of Babington against Queen Elizabeth, detected*
by her Minister, Sir Francis Walsingham.

PAINTED BY ARTHUR WILLIAM DEVIS, ESQ.

In the centre of the Picture is Queen Elizabeth, seated in a richly carved and gilt elbow chair, near a table, covered with green velvet. She is pointing to the picture of Babington and his six associates ; and recognizing one of them in the person of Barnwell, whom she knew, is pointing it out to her secretary, Sir Francis Walsingham, who stands on her left, adorned with the insignia of Chancellor of the Order of the Garter, with one of the intercepted letters in his hand.

Behind him, are three ladies in waiting ; the youngest of whom seems surprised at this wicked attempt on the life of her beloved

Sovereign. Over their heads on the side of the room, is the Portrait, whole length, of Henry the Eighth.

To the right of Her Majesty, behind the table, is a Nobleman (an Officer of the Household) earnestly viewing the picture, which is supported by the Artist himself. On the table is a small Greek Plato (a language the Queen was perfectly skilled in), Luther, and another book, in rich velvet bindings.

The foreground is occupied with a rich carved and gilt chair, of variegated satin damask, on which the Queen's favourite lap dog has seated himself.

The scene of this picture is laid in Her Majesty's closet, wainscoted with oak, a rich window curtain of crimson damask, with a carved and gilt cornice to correspond with the chairs. Behind this curtain is a large bow window; the upper part of which contains the Arms of England, the Prince's Plume, the Portcullis used by the House of Lancaster, and three other Crests, adopted by Queen Elizabeth. All these are in stained glass, together with the White and Red Roses united, surmounted with a Crown which is placed underneath the part of the window that is open:

Through the window is seen a turret, which terminates this part of the picture.

Authorities for the Portraits, Costume of the Dresses, Furniture, &c.

QUEEN ELIZABETH's Portrait has been formed from those that are found of her which best agree with the memoranda in the pocket book of Isaac Oliver, relative to Queen Elizabeth being painted without shadow (vide Walpole's Anecdotes of Royal and Noble Authors); but more especially from the subjoined extract from

Paul Hentzner's Travels into England in the Year 1598, printed
at Strawberry Hill, 1757, pages 48, 49.

" Next came the Queen, in the sixty-fifth year of her age,* as
" we were told, very majestic ; her face oblong, fair but wrinkled;
" her eyes small, yet black and pleasant ; her nose a little hooked ;
" her lips narrow, and her teeth black (a defect the English seem
" subject to from their too great use of sugar.) She had in her ears
" two pearls, with very rich drops. She wore false hair, and that
" red. Her bosom was uncovered, as all the English Ladies have
" it till they marry : and she had on a necklace of exceeding
" fine jewels ; her hands were small, her fingers long, and her
" stature neither tall nor low ; her air was stately, her manner of
" speaking mild and obliging."

In addition to the above excellent description, all the prints
since engraved from the pictures of Queen Elizabeth have been
consulted ; and a drawing from her effigy on her tomb in West-
minster Abbey, which is not ill executed, has furnished a hint to
complete her Portrait.

The Portrait of Sir Francis Walsingham is taken from Houbra-
ken's Heads of Illustrious Persons : the dress and shoes in parti-
cular are taken from a Picture at Penshurst, Kent, the seat of the
gallant Sir Philip Sidney. The dresses of the female attendants
on the Queen, have been collected from the tombs of Westminster
Abbey.

Granger makes no mention of any engraved portraits of the
conspirators, nor, on enquiry, does it appear that any exist : per-
haps from the reason before mentioned. The picture which Sir

* At the time of Babington's conspiracy she was in her fifty-fourth year.

Francis Walsingham caused to be presented to Queen Elizabeth in all probability shared the same fate.

The furniture has been copied from that at Penshurst, which, it is worthy of remark, its gildings, satins, &c. still remain in the highest state of preservation,

The arms and crests are derived from the MSS. in the Herald's College; from whence also the insignia of the Order of the Garter, as worn by the Chancellor at that period, was likewise communicated to the Artist.

The Royal Library, abounding with every curious specimen of books in costly bindings, in various coloured velvets, with gold and silver clasps, enriched with pearls and precious stones, furnished examples for those represented on the table before the Queen.

25 *Sir Philip Sidney, mortally wounded, rejecting the water offered to him, and ordering it to be first given to a wounded Soldier.*

PAINTED BY BENJAMIN WEST, LATE P.R.A.

The centre of this composition is occupied by the wounded hero, Sir Philip Sidney, seated on a litter, who, whilst his wound is dressing by the attending surgeons, is ordering the water (which is pouring out for him to allay the extreme thirst he suffered from the loss of blood) to be given to a wounded soldier, to whom he points, in the second group to his right, and who casts a longing look towards it. Behind, and to the left of Sidney, his uncle, the Earl of Leicester, in dark armour, is discovered, as Commander in Chief, issuing his orders to the surrounding cavalry, as engaged in the confusion of the contending armies. Among the several spirited war-horses that are introduced, that of

Sidney's, a white horse, is seen under the management of his servant, but still restive and ungovernable. The Portrait of the Artist is found to the left of the picture, the figure leaning on a horse in the fore-ground, and contemplating the interesting scene before him. The back-ground, and to the extreme distance of the horizon, the movements of the armies, and the rage of battle are every where visible, enveloped in an atmosphere that has fixed upon it the true aspect of danger and dismay, as legibly as the plastic art can possibly depict their terrors to the feeling mind.

26 *The Wife of the Neat-herd rebuking King Alfred, (who had taken refuge in their Cottage, disguised as a Peasant) for having suffered her Cakes to burn, which she had committed to his care.*

500 Gs

PAINTED BY DAVID WILKIE, ESQ.

In the centre of the composition Alfred is represented sitting, with his bow, on which he had been employing himself in preparing it for use.

To the left are the neat-herd, with his wife and daughter, who are supposed to have just come in with some fuel for the fire. The wife is reprimanding Alfred, as the cause of the burning of her cakes, and the daughter is endeavouring to save what remains of them, by blowing them with her mouth, while the neat-herd himself (knowing his guest to be the King), is afraid that his good-nature will be overcome by his resentment, from the rude expressions and irritating language of his wife. The young man in the back ground to the right, with the game on his back,

is a Portrait of the Artist as a peasant returning from hunting, and the woman he is talking with is an inmate of the house, employed in kneading the dough, in preparation for its being made into cakes for the family, A dog appears to have laid claim to a share of the spoils, which he endeavours to devour beneath the table.

The interior of the cottage is appropriately filled with a variety of rustic implements and utensils, denoting the station its inhabitants held in that early period of civilization in Britain. The harp of Alfred is also introduced, suspended on the wall.

27 *The 'Death of the Earl of Chatham.*

PAINTED BY JOHN SINGLETON COPLEY, ESQ. R. A.

The luminous talents and exalted character of the great Statesman whose death is recorded in this distinguished example of British art ; the singular coincidence of time and place, in which the world was deprived of its brightest ornament of intellectual excel-lence ; added to the elevated dignity and eminent abilities of the other noble personages represented, are circumstances that cannot but have their full force on the minds of Englishmen, in this and in ages to come; whenever they shall contemplate this perform-ance. The powers of the pencil thus transmitting the august glories of that period to futurity, whilst they have evinced the present high state of national talent in this first walk of the graphic Muse, call most imperiously and most persuasively also on the patriotism and the liberality of the affluent, to enrich their country and posterity with similar examples of excellence in art, on subjects of great national importance, and worthy of such

superior illustration. It is the duty of the present, possessing the means, to confer that benefit on future times.

The point of time chosen for this composition is that in which the late Earl of Chatham received in the House of Lords the awful stroke which ultimately closed his illustrious life. His three sons, and his son-in-law (Lord Viscount Mahon, the late Earl Stanhope) being present, surround their dying father, who is supported by his Royal Highness the Duke of Cumberland, and his Grace the Duke of Portland. To the left of, and near the Earl of Chatham, his Grace the Duke of Richmond is represented standing, holding a paper in his hand, marked with the subject then in debate; and in an attitude expressive of the calamitous and unexpected event which had taken place on the Noble Earl, in the moment he was rising to reply. This group, which forms the principal one of the picture, is enlarged by the introduction of other Peers, to nearly half the number contained in the whole composition. The second group consists of the great Officers of State; and the third of the Right Reverend the Bishops and other Peers : these fill the whole fore-ground of the picture. On the middle-ground, the Lord Chancellor and the Judges are represented on the wool-packs ; and the Sons of Peers in the back-ground, on the steps of the Throne.

28 *Stephen Langton, Archbishop of Canterbury, shewing to the Barons of England, in the Abbey of St. Edmund at Bury, the Charter of Liberties that had been granted by King Henry the First, and on which the Great Charter of King John was subsequently founded.*
PAINTED BY ARTHUR WILLIAM DEVIS, ESQ.

The persons of the Barons are represented by their descendants, in the following order. *Vide the Heraldic Devices.*

1 Oliver D'Eincourt, Baron de Blankney, by Henry Earl of Shannon
2 William, Baron de Blancminster, alias Whitchurch, by George Earl of Morpeth
3 William Le Belward, Baron de Malpas, by George Earl of Rocksavage
 Ralph, Baron de Gernon, by William Duke of Devonshire
4 William Le Mareschal, Earl of Pembroke, by Francis Marquis of Tavistock
6 Robert Beauchamp, Baron de Hacche, by Francis Marquis of Hertford
7 Henry, Baron de Neville, by Thomas Lord Erskine
8 John Fitz-Alan, Baron of Clun and Oswestry, by George, Earl of Egremont
9 Henry, Baron de Audley, by Charles, Lord Ossulston
10 Thomas Maudit, Baron of Somerford Maudit, by William, Earl of Darlington
11 Gilbert de Clare, Earl of Gloucester and Hereford, by George, Marquis of Stafford
12 Roger de Mortimer, Baron of Wigmore, by George, Earl of Galloway
13 William de Warren, Earl of Warren and Surrey, by George, Earl of Morton
14 Saier de Quincy, Earl of Winchester, by Francis, Marquis of Hastings
15 Robert de Vere, Earl of Oxford, by George, Marquis of Huntley
16 Richard, Baron de Percy, by Hugh, Duke of Northumberland
17 Henry de Bohun, Earl of Hereford, by Henry, Viscount Hereford
18 Robert de Ros, Baron of Hamlake, by John, Duke of Rutland

FINIS.

Gold and Walton, Printers, 24, Wardour Street.